D1616078

A Keepsake

CAPE COD
ALONG THE SHORE

Arthur P. Richmond

4880 Lower Valley Road • Atglen, PA 19310

To Jared Pratt

INTRODUCTION

The ocean has always fascinated people. From time immemorial people have ventured to the shoreline, and today we continue to watch the sun emerge from the water, spend the day relaxing, swimming, beachcombing, surfing, fishing, or observing the natural surroundings. As the day draws to a close, we watch, almost mesmerized, as the sun slowly sinks into the western sky and its colors wash over the shore.

One of the finest places to enjoy these activities is that finger of sand extending from mainland Massachusetts into the Atlantic Ocean: Cape Cod with its pristine and unspoiled beauty.

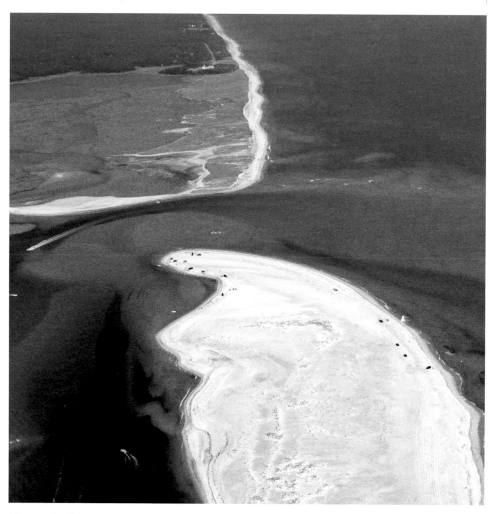

Nauset Inlet along the outer beach.

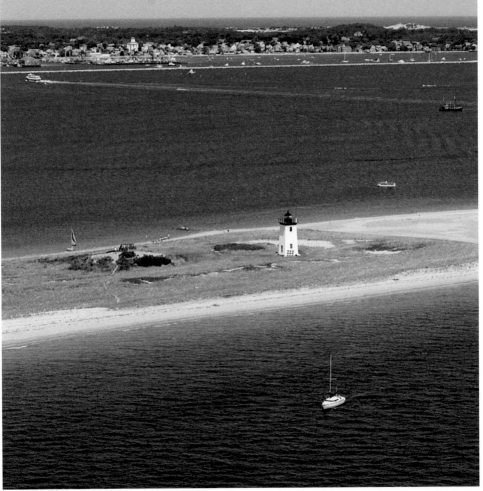

Long Point Light with Provincetown in the distance.

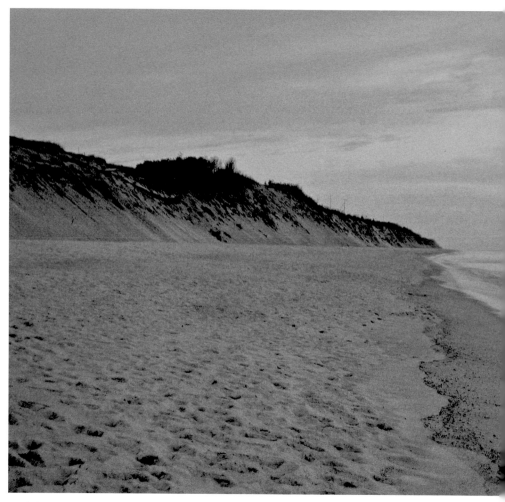

Early light shines on the dunes.

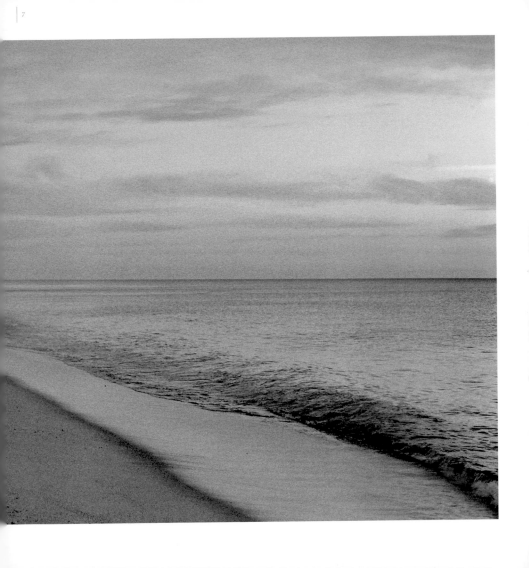

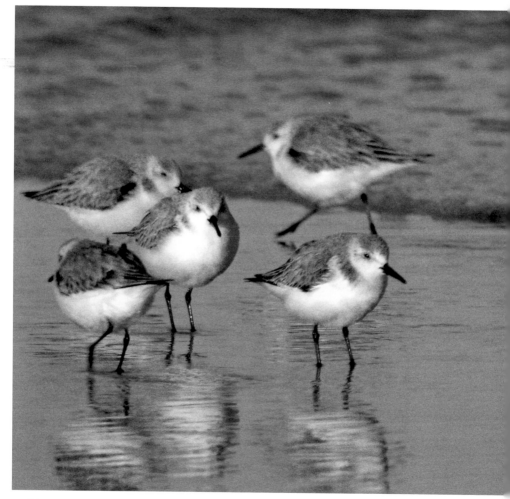

Ruddy turnstones along the shore.

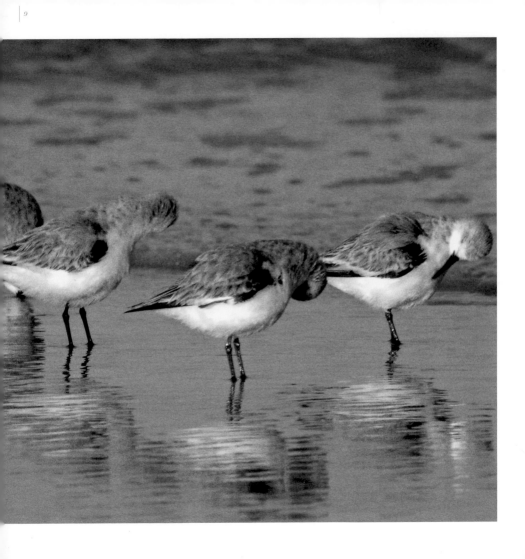

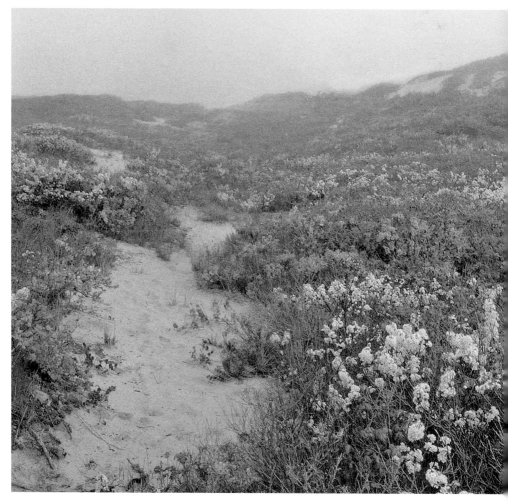

Beach plums bloom in the Provincetown dunes.

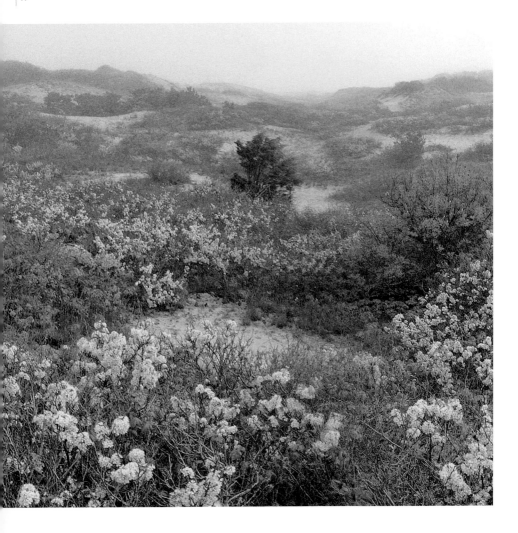

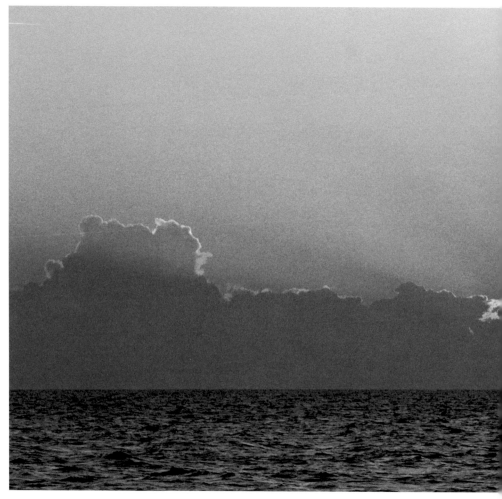

The first rays of sunlight welcome a new morning.

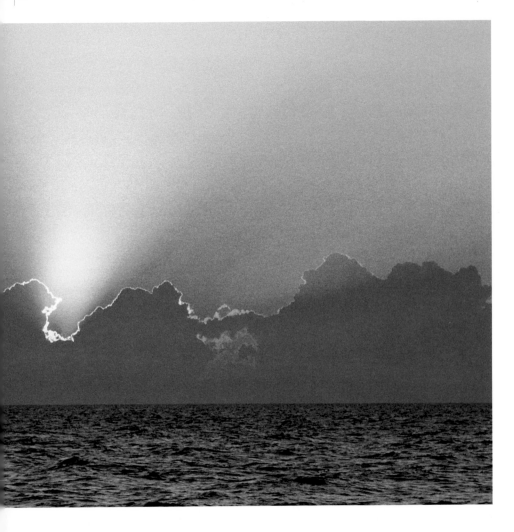

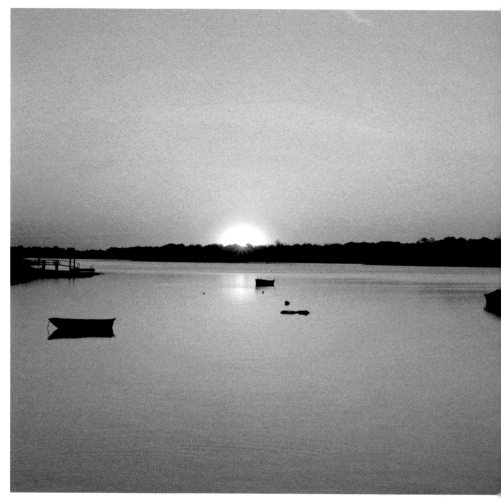

Sunrise in Town Cove.

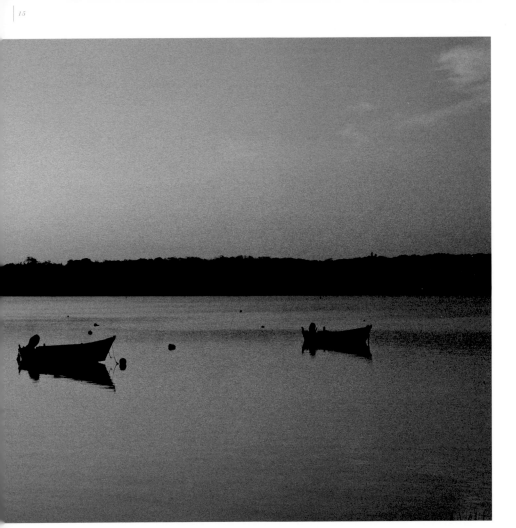

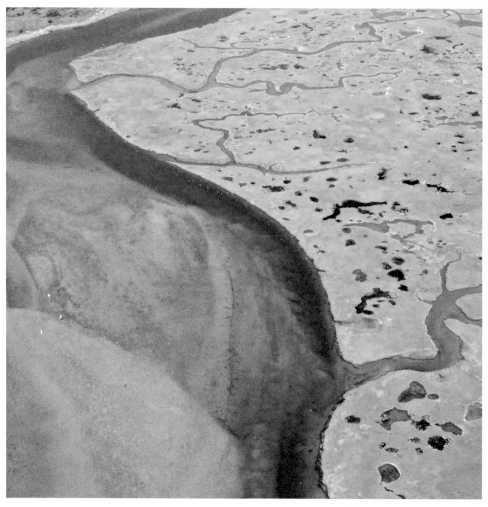

A meandering channel in Nauset Marsh.

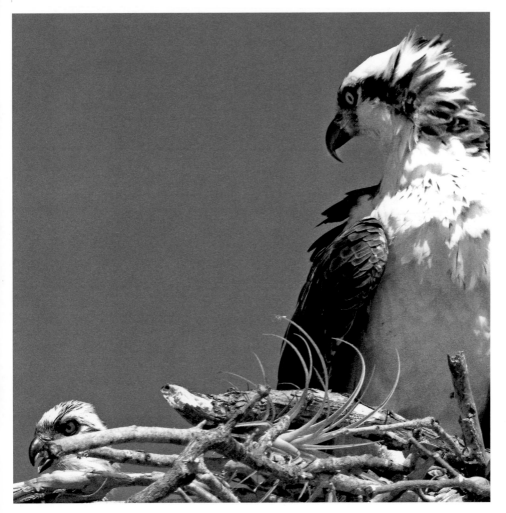

An osprey with a nestling.

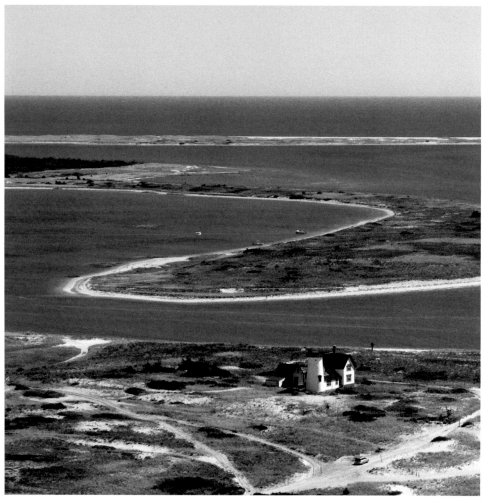

The no-longer-active Stage Harbor Light in Chatham.

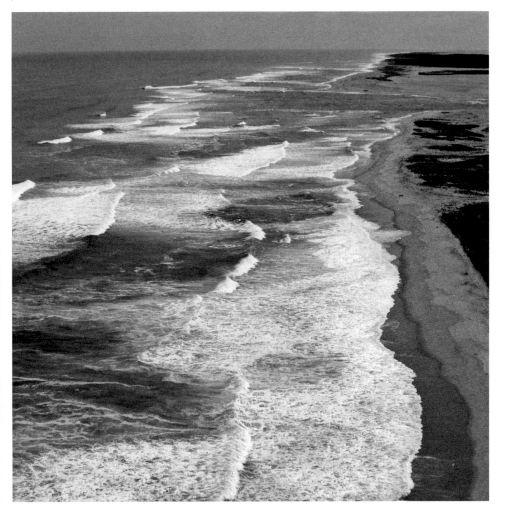

Surf breaks along the shore.

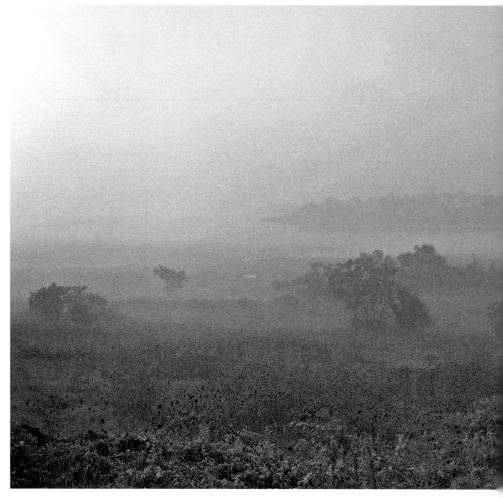

Nauset Marsh on a foggy morning from Fort Hill.

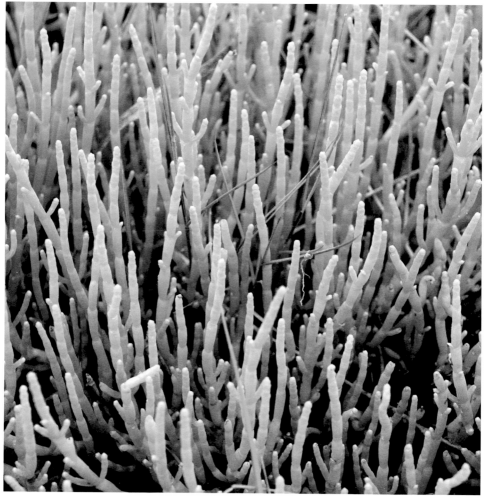

Glasswort grows among the marsh grasses.

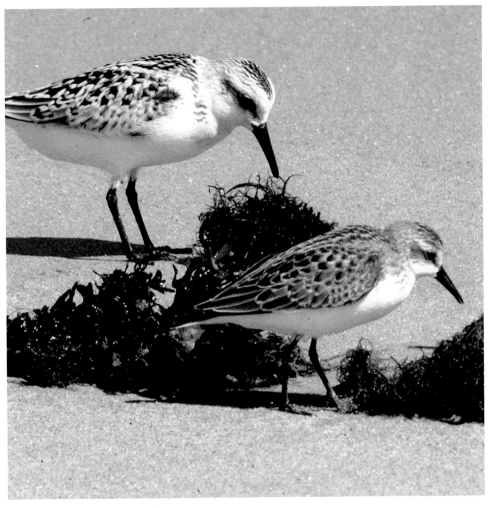

Sandpipers feed along the beach.

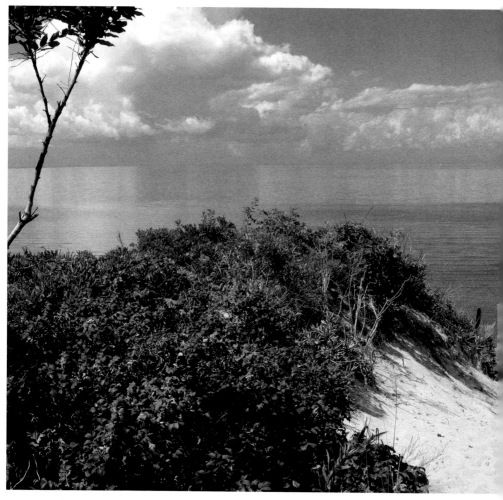

A sandy path leads to a beach.

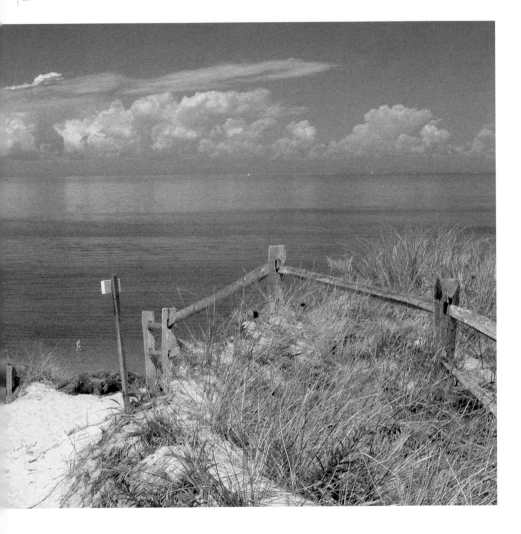

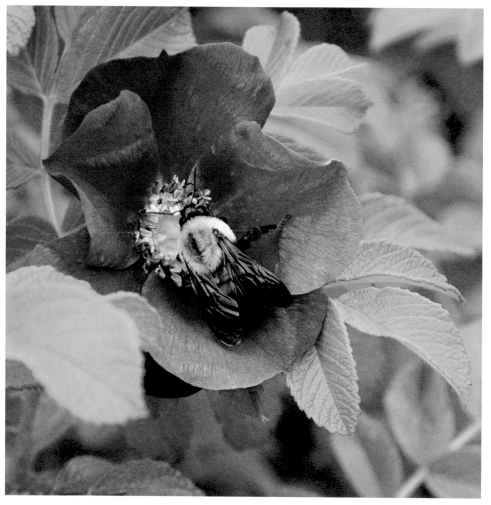

Feeding time on a beach rose.

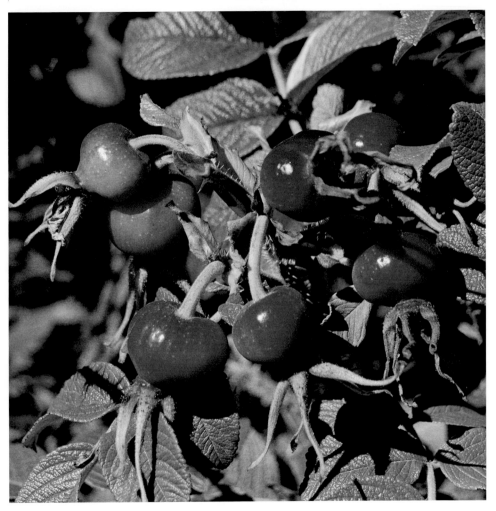

Rose hips develop after the flowers have bloomed.

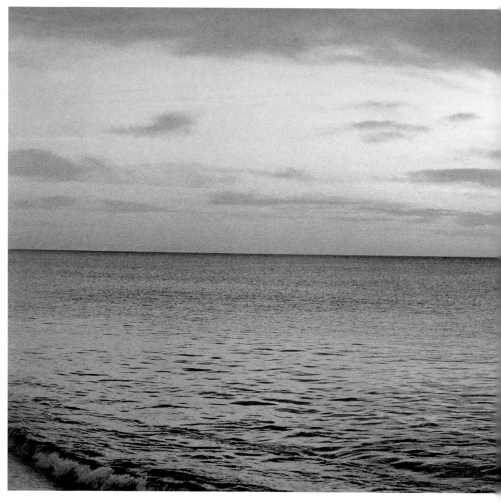

Sunrise over a calm sea.

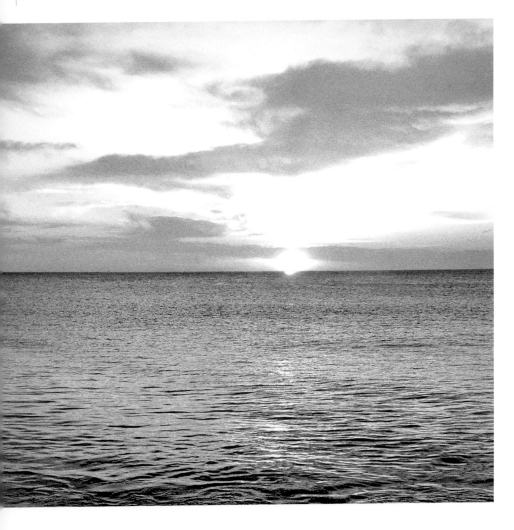

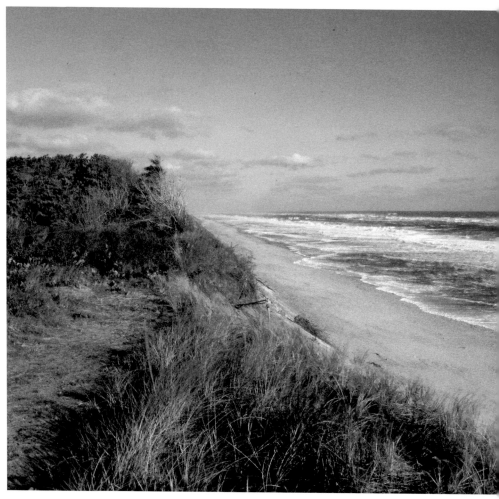

The dunes and the outer beach.

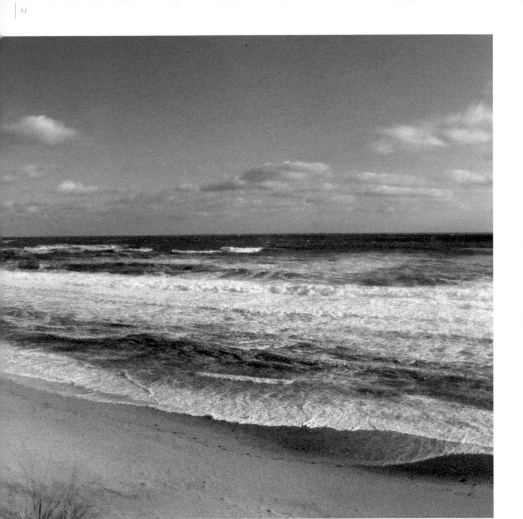

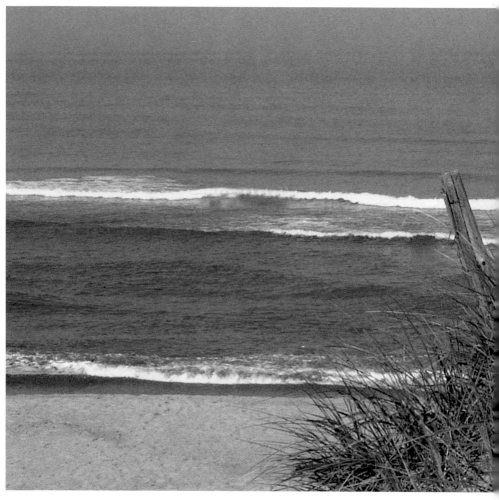

A storm fence on the ocean shore.

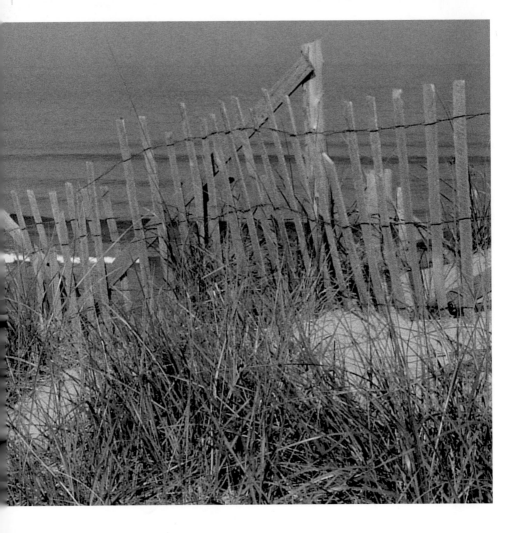

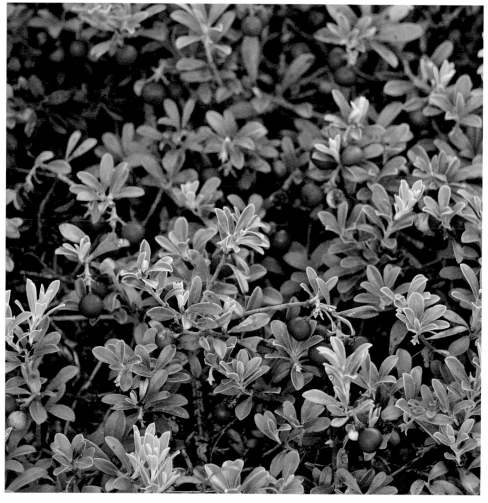

Bearberry is a ground cover found behind the dunes.

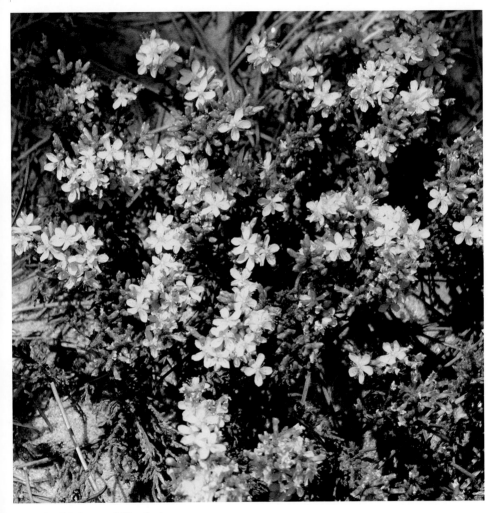

Beach heath helps to stabilize the dunes.

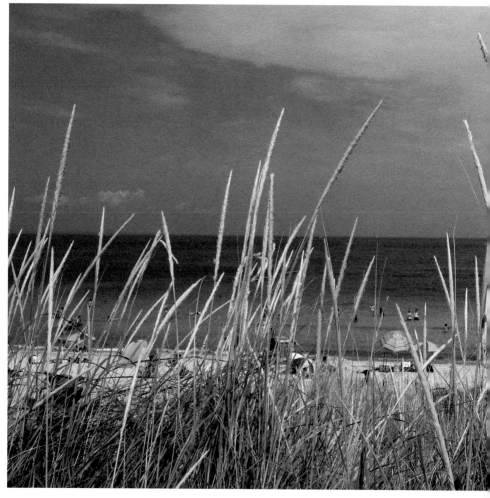

A beach beyond the dunes.

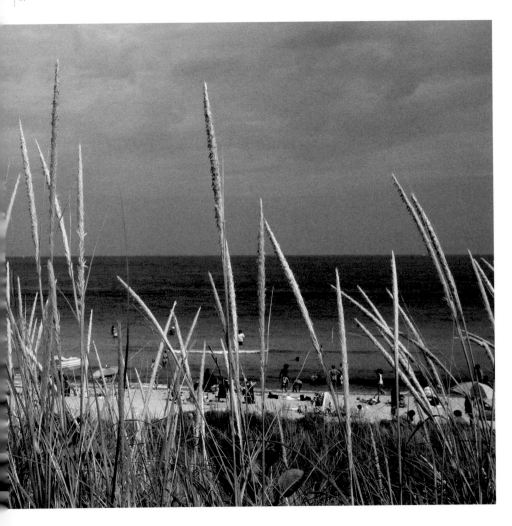

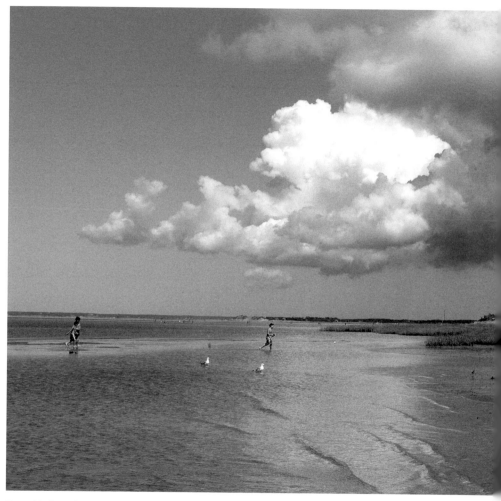

Low tide, bayside.

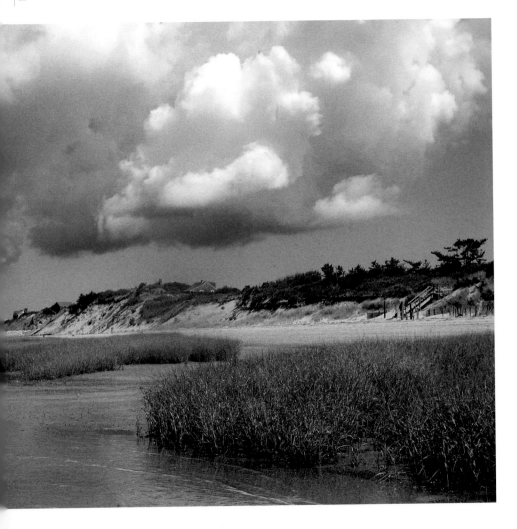

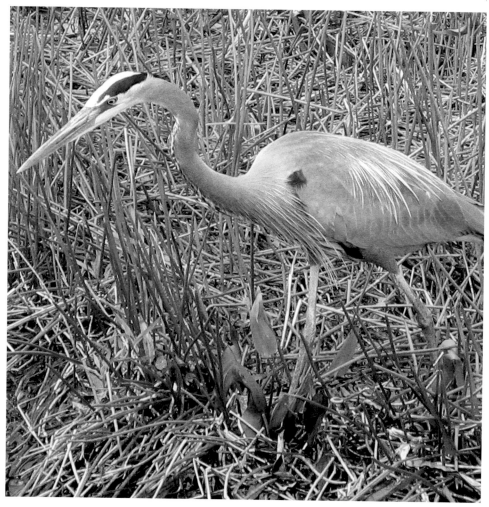

A great blue heron feeding in the marsh.

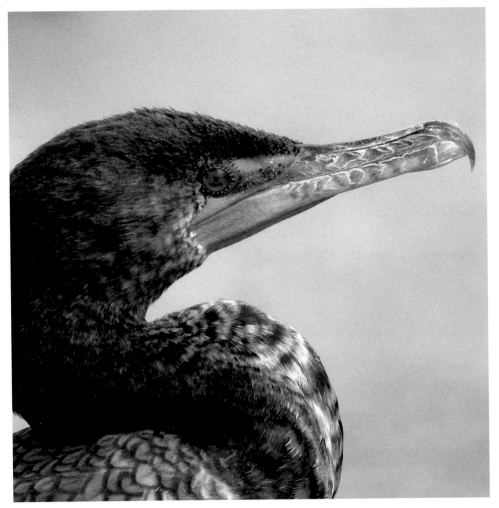

The double-crested cormorant is well-equipped to feed on fish.

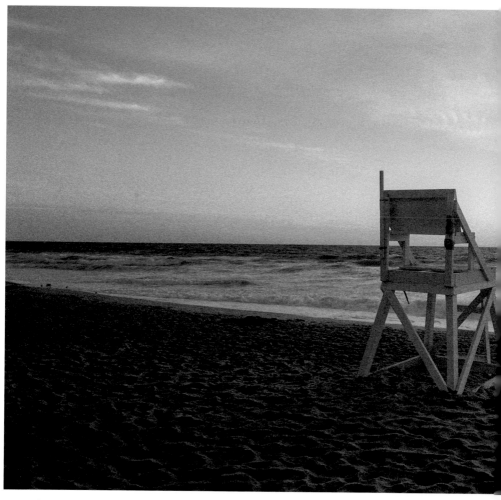

Too early for the lifeguards.

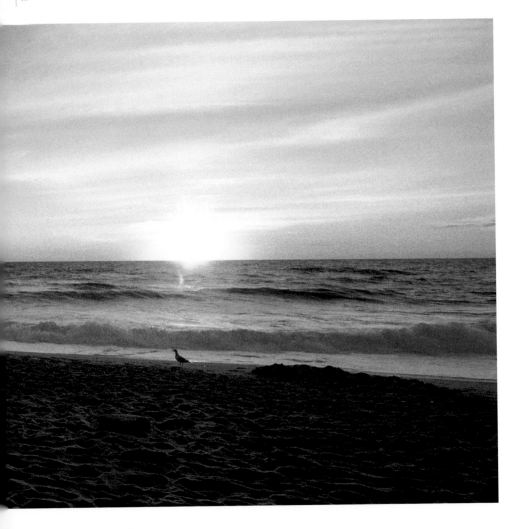

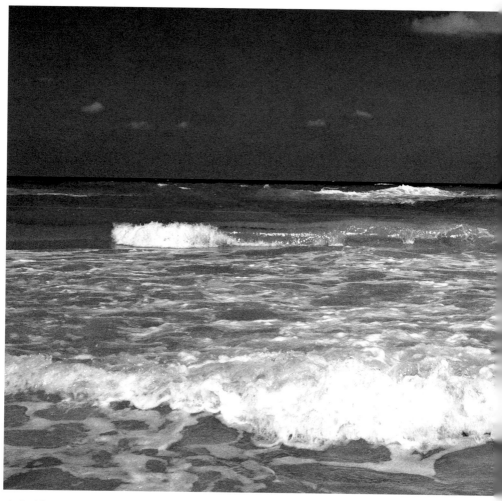

An inviting ocean.

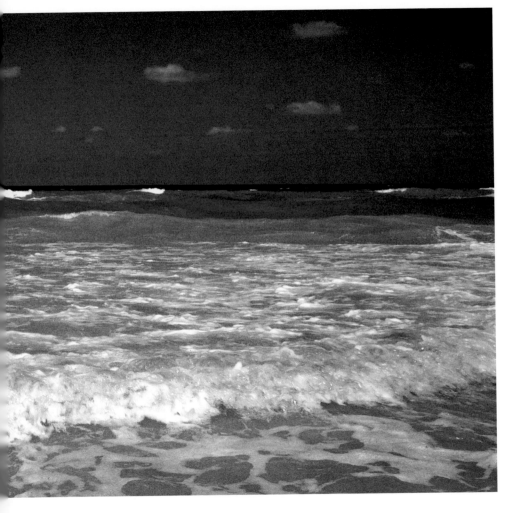

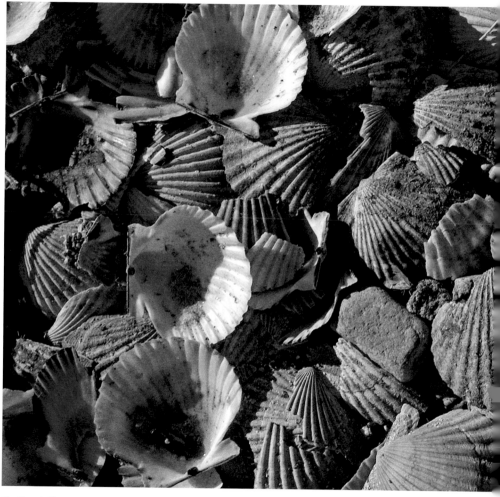

Scallop shells.

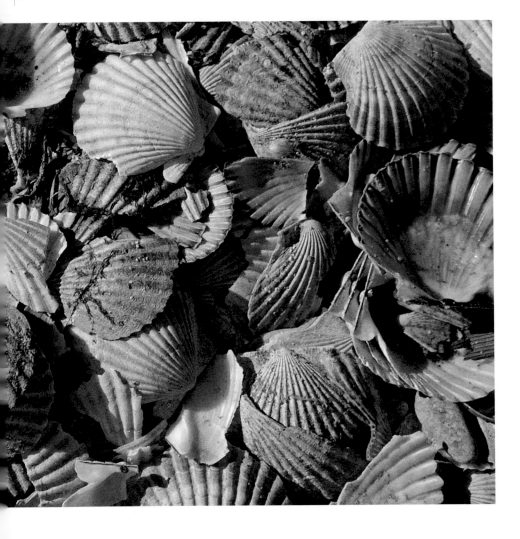

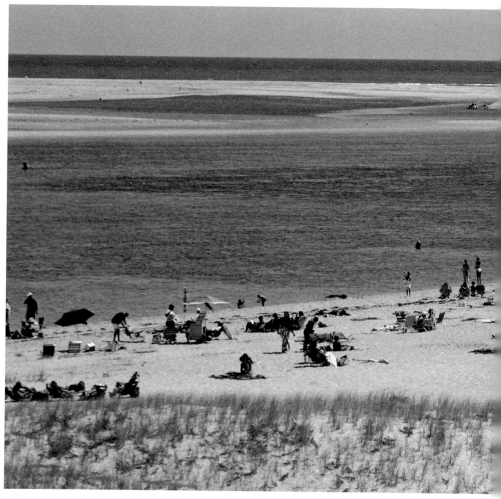

Lighthouse Beach at Chatham Inlet.

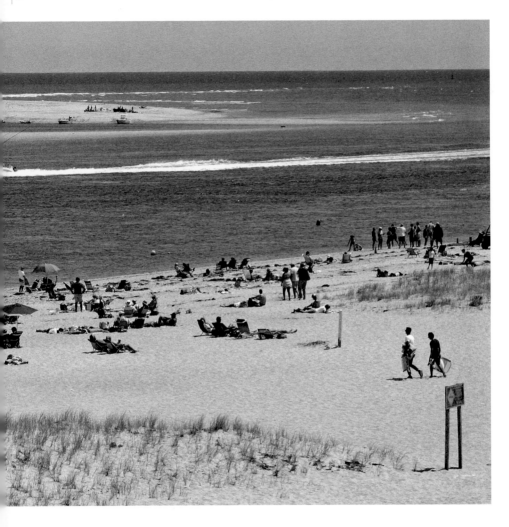

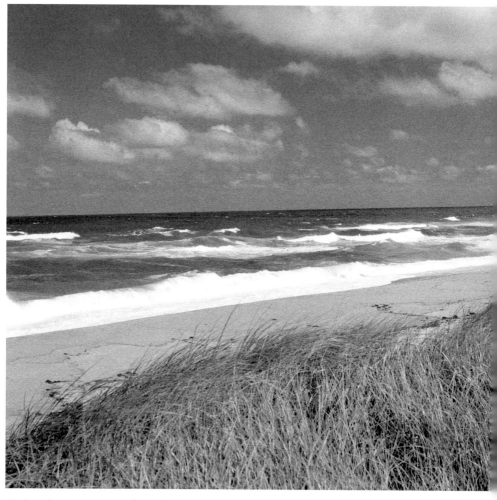

Surf, sand, and dunes on the Outer Cape.

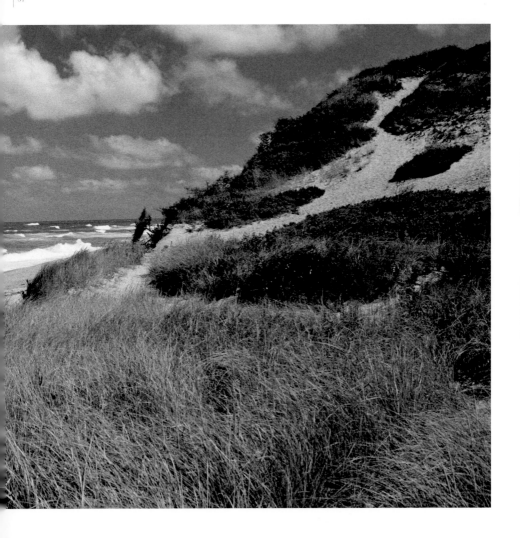

Some grasses are salt tolerant and grow in the marsh.

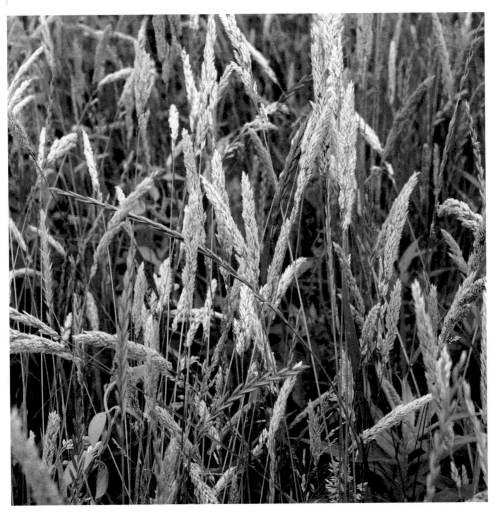

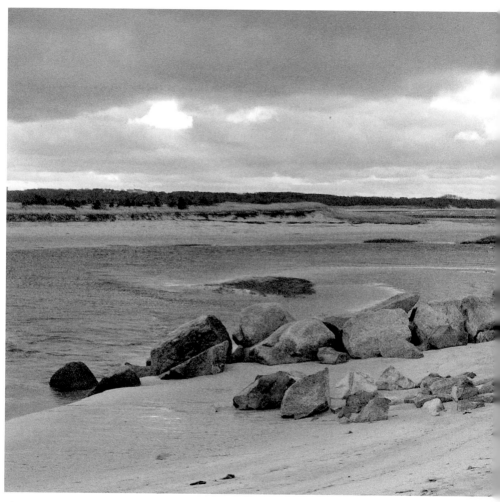

An approaching storm at Paine's Creek in Brewster.

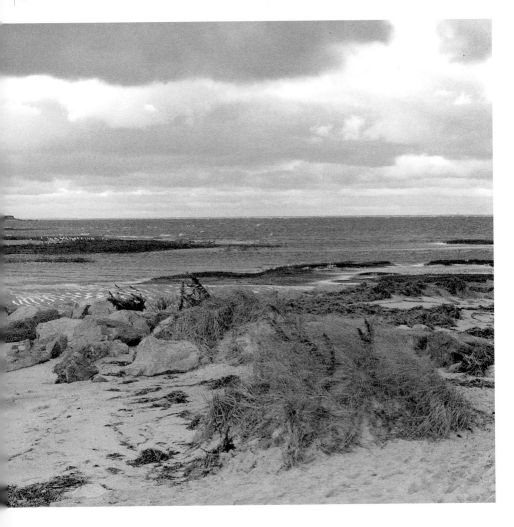

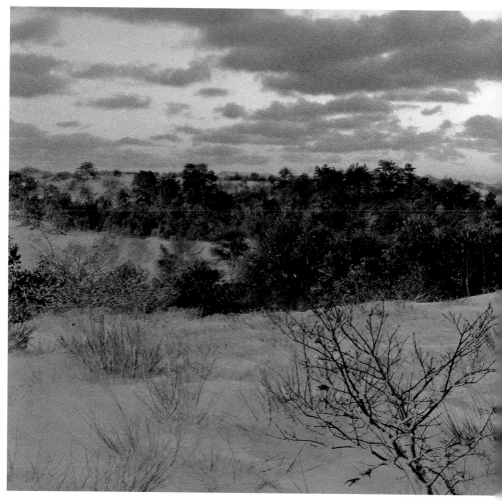

On a winter morning, the sun rises over Provincetown dunes.

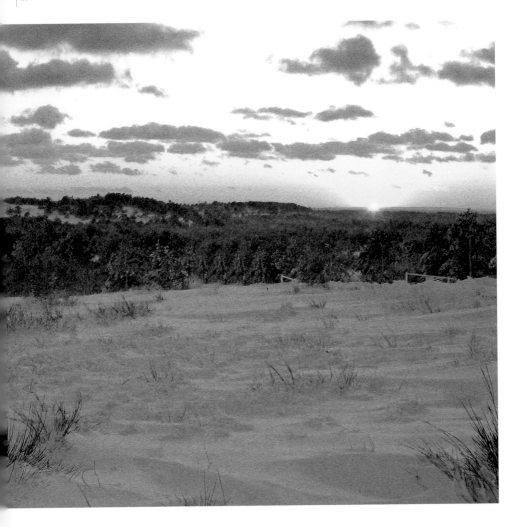

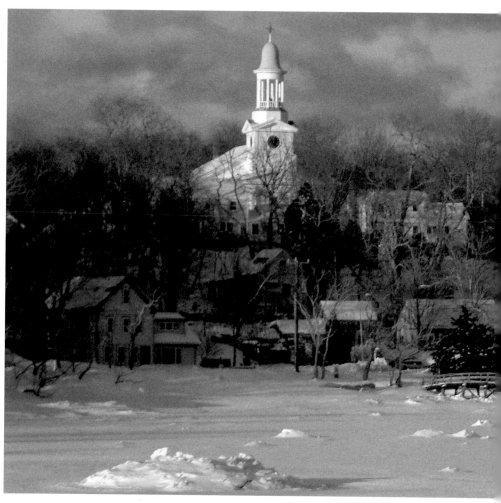

Duck Creek in Wellfleet.

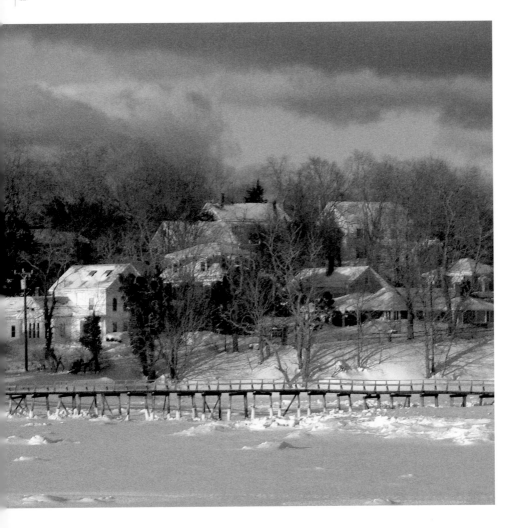

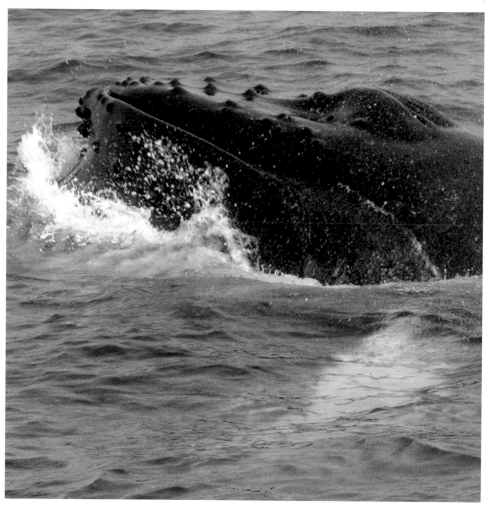

Whales feed near the surface.

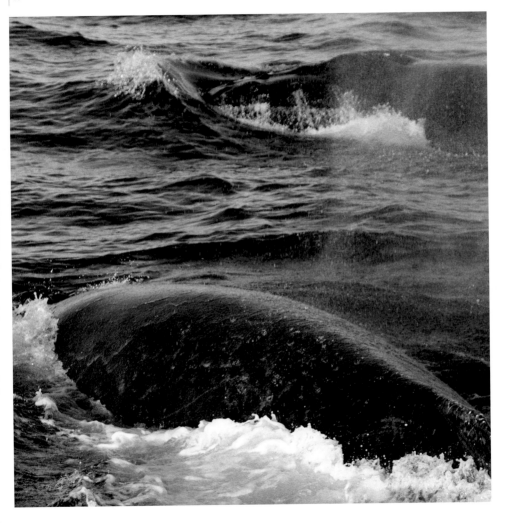

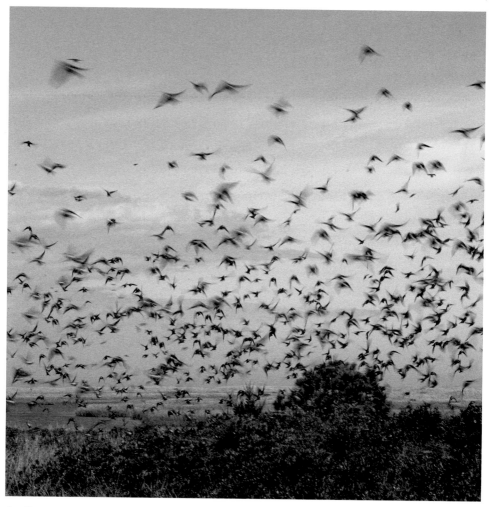

Swallows soar around the dunes.

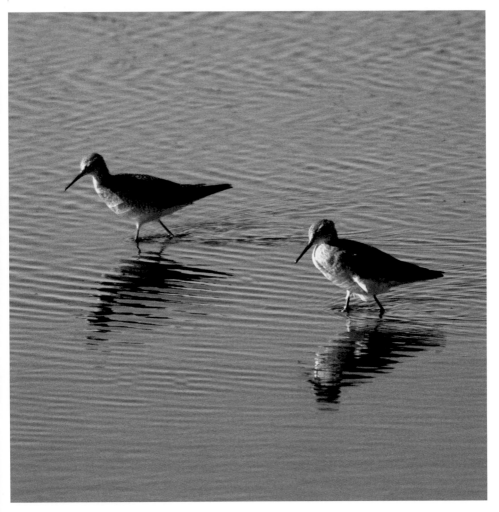

Yellowlegs feed in the shallows.

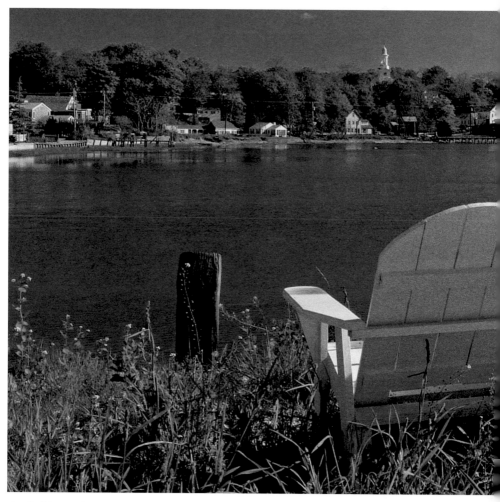

Overlooking Duck Creek in Wellfleet.

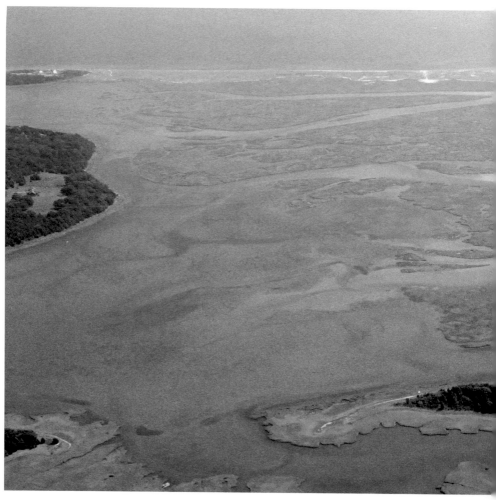

Nauset Marsh was once a deep-water harbor.

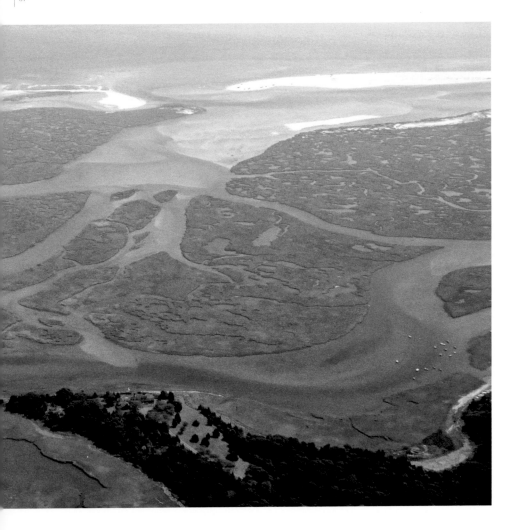

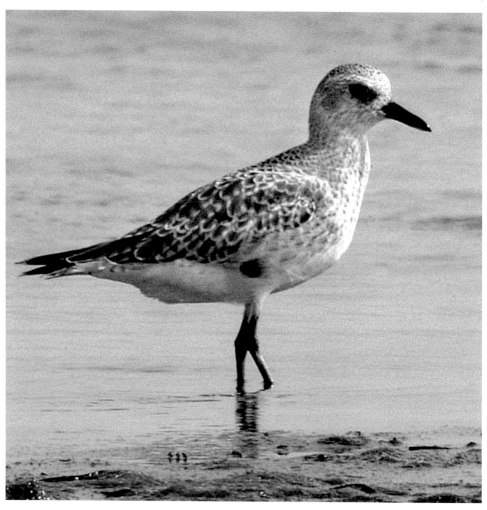

A black-bellied plover in winter plumage.

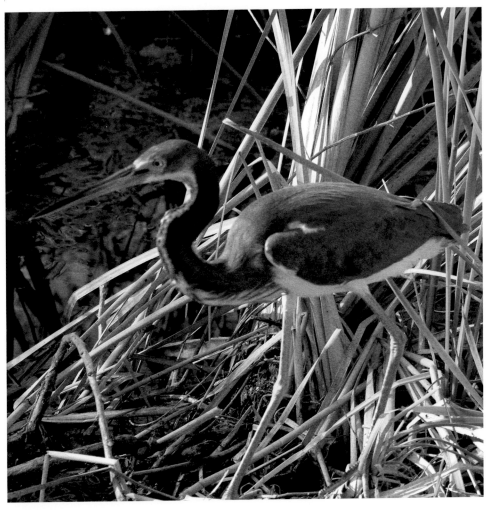

A tricolored heron stalking prey.

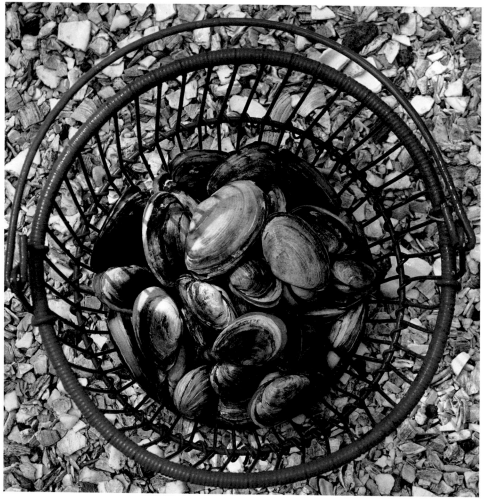

A bucket of steamers.

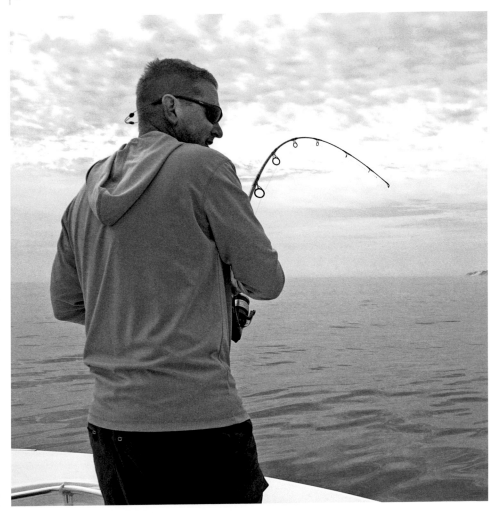

Tight lines.

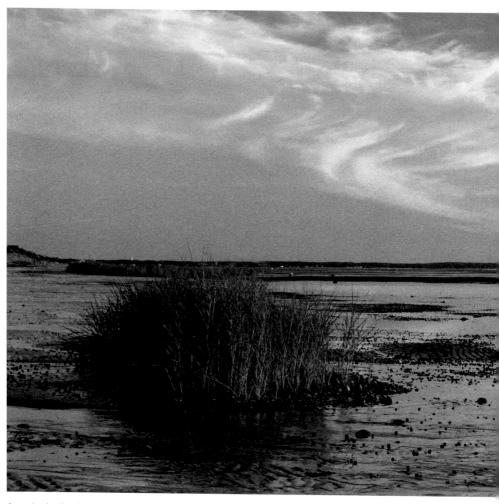

Late in the day, bayside.

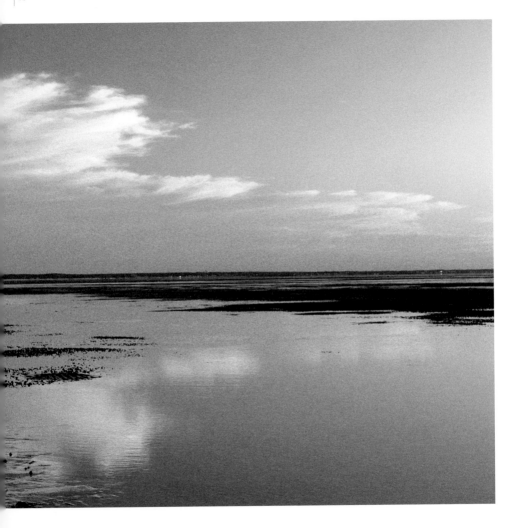

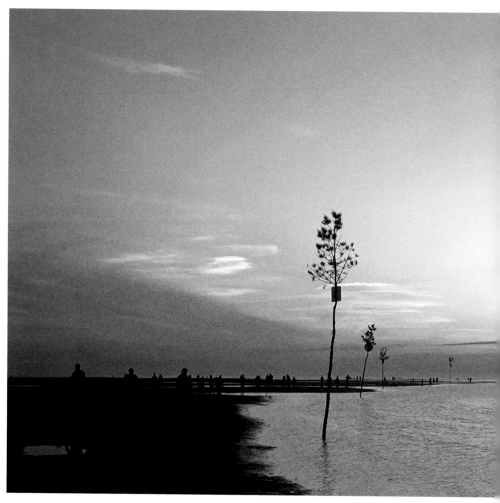

Almost gone.

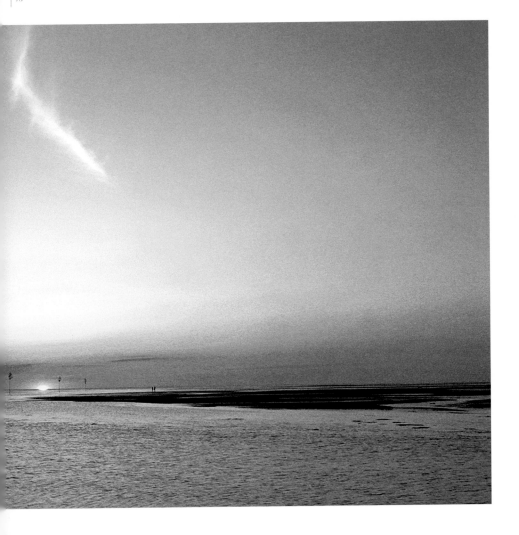

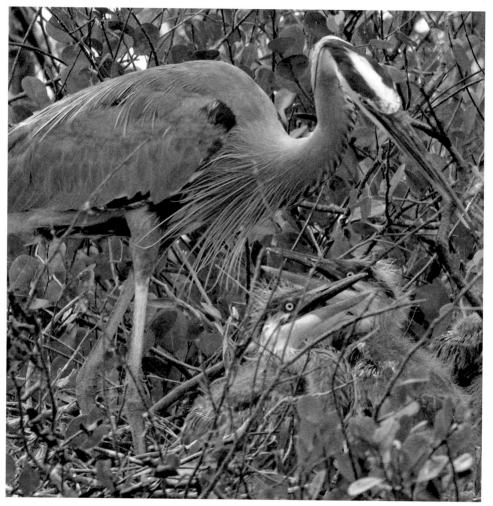

The great blue heron on a nest.

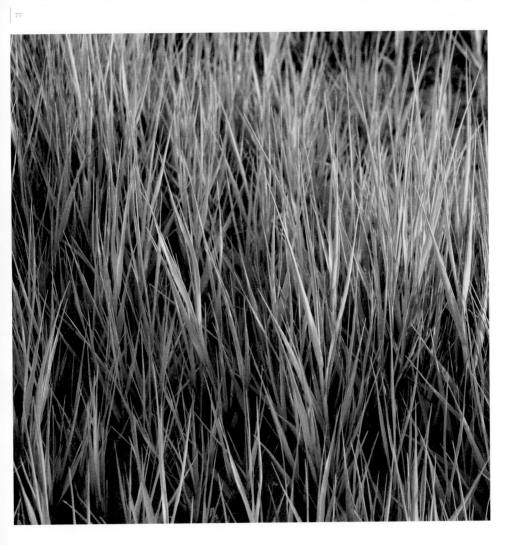

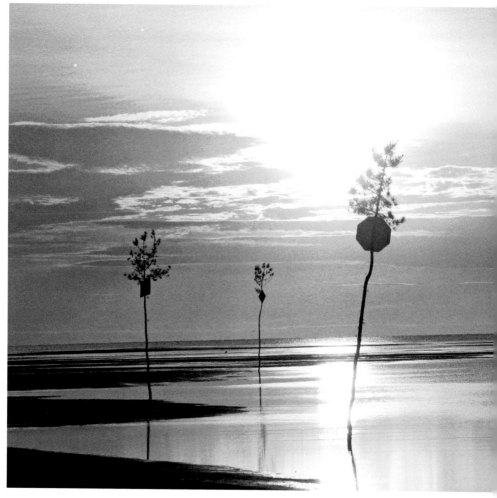

About half an hour before sunset at Rock Harbor.

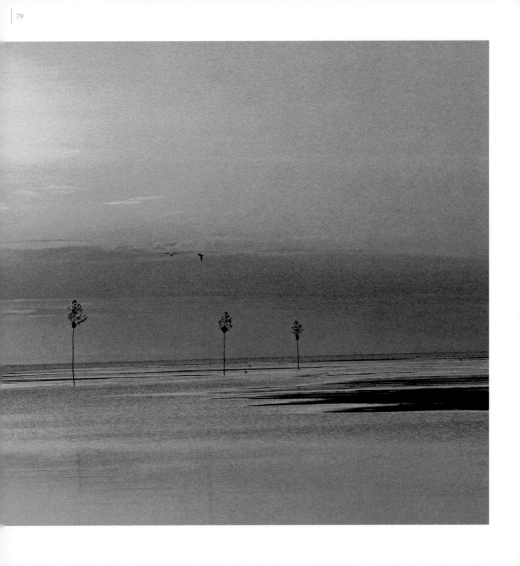

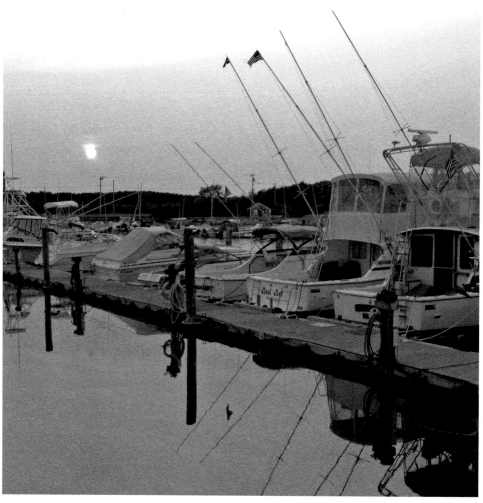

A setting sun in summer . . . and in winter.

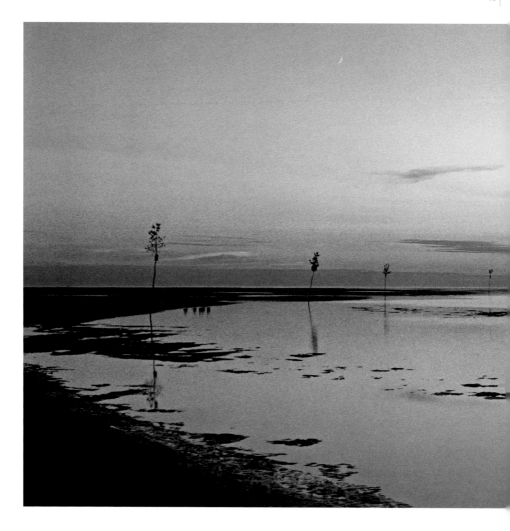

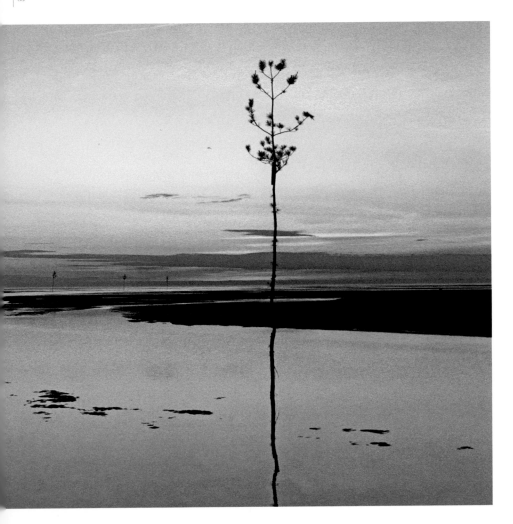

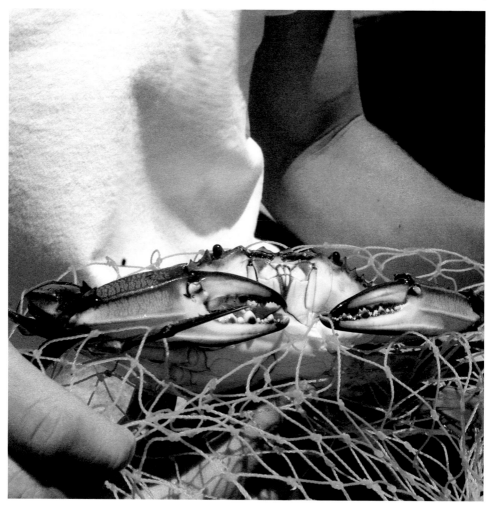

Crabbing is popular in the creeks.

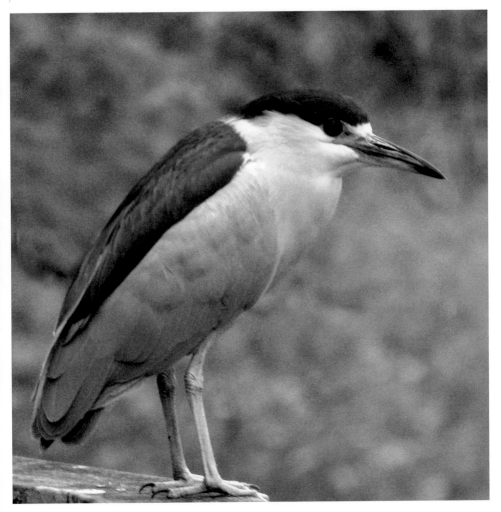

The black-crowned night heron is usually a nocturnal feeder.

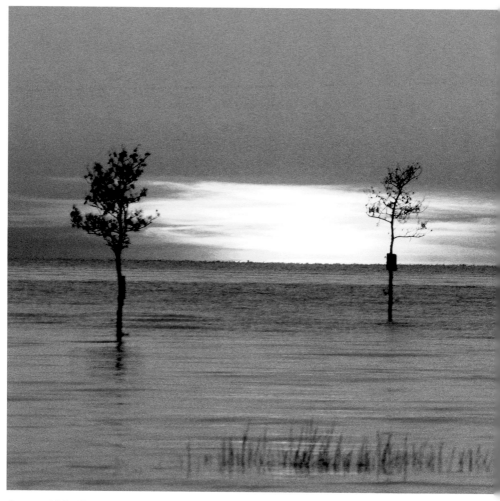

Sunset at high tide, Rock Harbor.

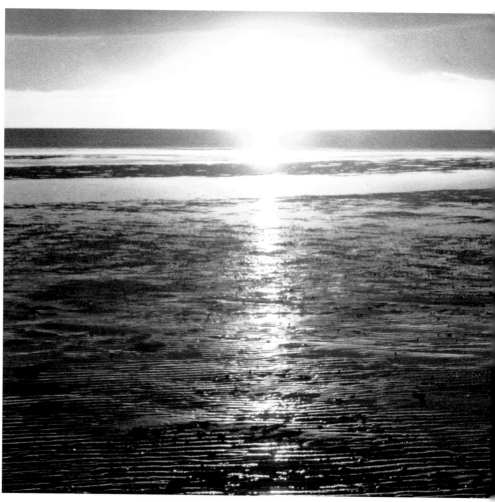

Sunset at low tide along the bay.

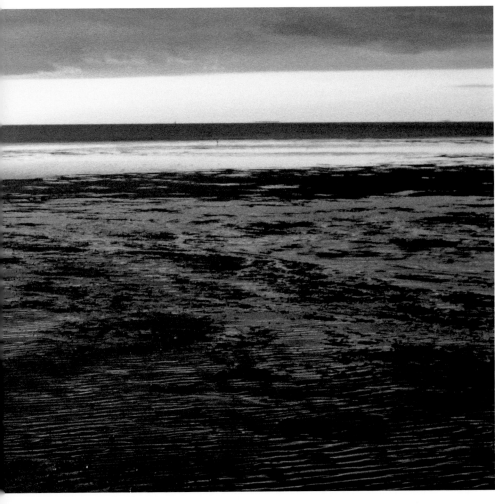

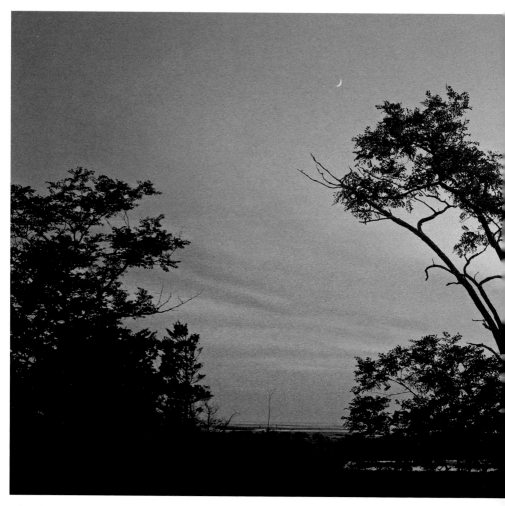

The afterglow at Bea River.

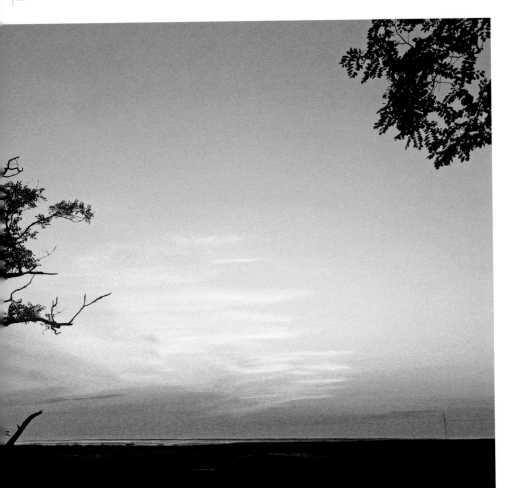

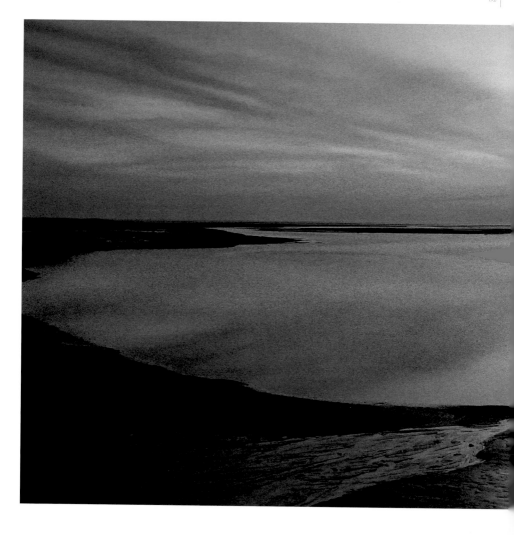

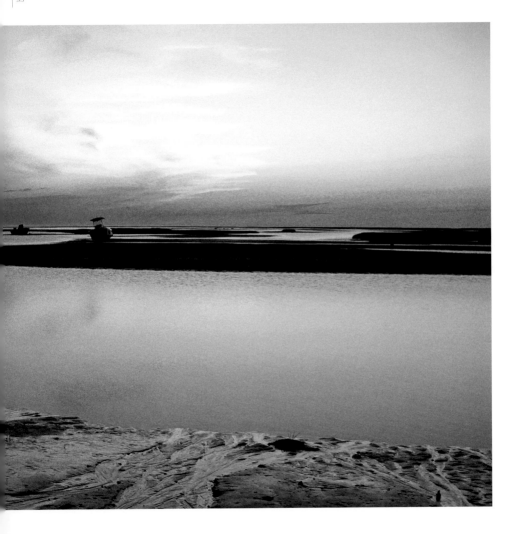

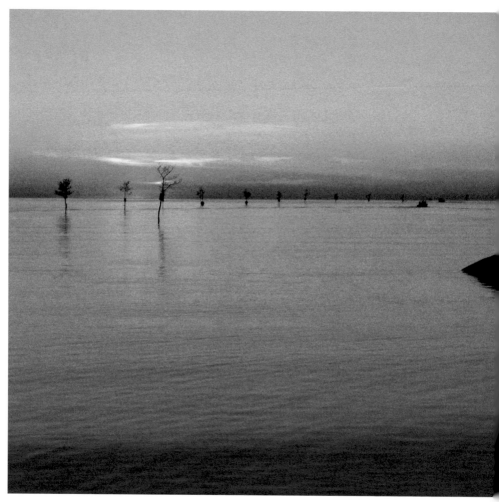

Last light, Rock Harbor jetty.

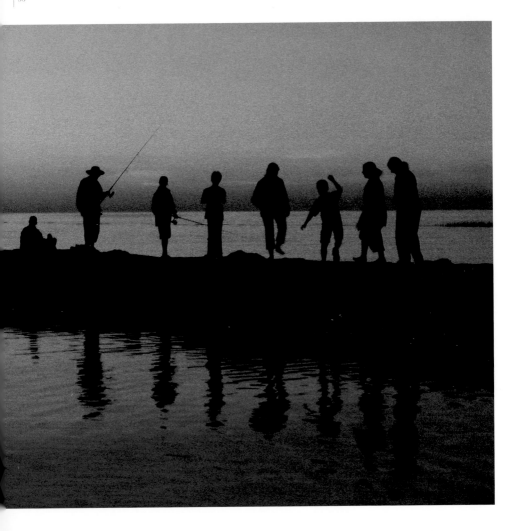

Arthur P. Richmond has been a
photographer for more than fifty years.
He is the author of more than a dozen books,
and his images are also found in calendars
and postcards, as well as on display at
several galleries in Massachusetts.

Other Schiffer Books by the Author:
Harbors of Cape Cod & the Islands,
ISBN 978-0-7643-3007-0
Lighthouses of Cape Cod & the Islands,
ISBN 978-0-7643-2460-4
Cape Cod Wide, ISBN 978-0-7643-2776-6

Copyright © 2016 by Arthur P. Richmond

Library of Congress Control Number: 2016938498

All rights reserved. No part of this work may be reproduced or used in any form or by any means—graphic, electronic, or mechanical, including photocopying or information storage and retrieval systems—without written permission from the publisher.

The scanning, uploading, and distribution of this book or any part thereof via the Internet or any other means without the permission of the publisher is illegal and punishable by law. Please purchase only authorized editions and do not participate in or encourage the electronic piracy of copyrighted materials.

"Schiffer," "Schiffer Publishing, Ltd.," and the pen and inkwell logo are registered trademarks of Schiffer Publishing, Ltd.

Designed by Molly Shields
Type set in Bell MT

ISBN: 978-0-7643-5160-0
Printed in China

Published by Schiffer Publishing, Ltd.
4880 Lower Valley Road
Atglen, PA 19310
Phone: (610) 593-1777; Fax: (610) 593-2002
E-mail: Info@schifferbooks.com
Web: www.schifferbooks.com

For our complete selection of fine books on this and related subjects, please visit our website at www.schifferbooks.com. You may also write for a free catalog.

Schiffer Publishing's titles are available at special discounts for bulk purchases for sales promotions or premiums. Special editions, including personalized covers, corporate imprints, and excerpts, can be created in large quantities for special needs. For more information, contact the publisher.

We are always looking for people to write books on new and related subjects. If you have an idea for a book, please contact us at proposals@schifferbooks.com.